T0132232

Be The Light

Sgm

WestBow Press books may be ordered through booksellers or by contacting:

WestBow Press
A Division of Thomas Nelson & Zondervan
1663 Liberty Drive
Bloomington, IN 47403
www.westbowpress.com
1 (866) 928-1240

ISBN: 978-1-9736-4465-1 (sc)
ISBN: 978-1-9736-4466-8 (e)

Library of Congress Control Number: 2018913340

Print information available on the last page.

WestBow Press rev. date: 02/13/2019

WESTBOW
PRESS®
A DIVISION OF THOMAS NELSON
& ZONDERVAN

BEFORE HUMAN TIME

DARKENSS WAS.

NO ONE KNOWS HOW OR WHY,

IT JUST WAS.

A VOICE SAID

"LET THERE BE LIGHT"

AND THERE WAS LIGHT.

DARKNESS LAUGHED!

PLANNING TO EXTINGUISH THE LIGHT

DARKNESS HUFFED AND PUFFED

BUT COULD NOT BLOW THE LIGHT OUT

INSTEAD,

LIGHT BECAME BIGGER.

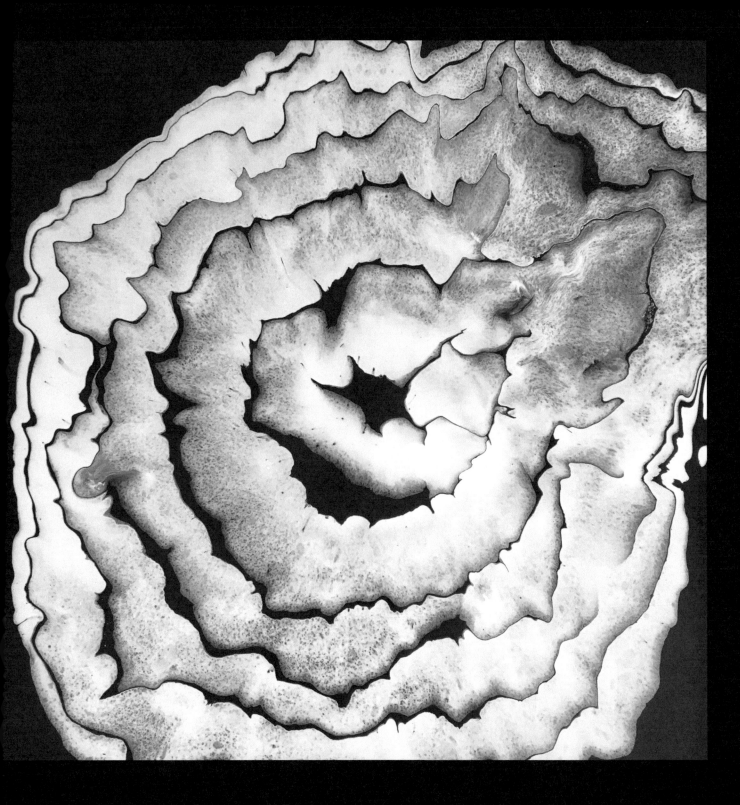

THE VOICE SAID,

"LET THERE BE
HEAVENS
AND
EARTH"

THE LIGHT GREW AND GREW

BUT

DARKNESS FORMED DEEP BLACK HOLES

READY TO SUCK IN THE LIGHT.

THE LIGHT WAS ECSTATIC WITH WHAT IT HAD CREATED, BUT WAS ALSO LONELY, SO LIGHT CREATED TINY LIGHTS TO LOVE!

WITH ALL OF THE LOVE, DARKNESS ONLY HAD ONE SPOT LEFT.

TINY LIGHTS WERE TOLD, BY LIGHT, TO NOT TOUCH THAT ONE SPOT.

THEY WERE TEMPTED, AND TOUCHED.

TINY LIGHTS WERE CAST OUT OF THE LIGHT AND INTO THE DARKNESS.

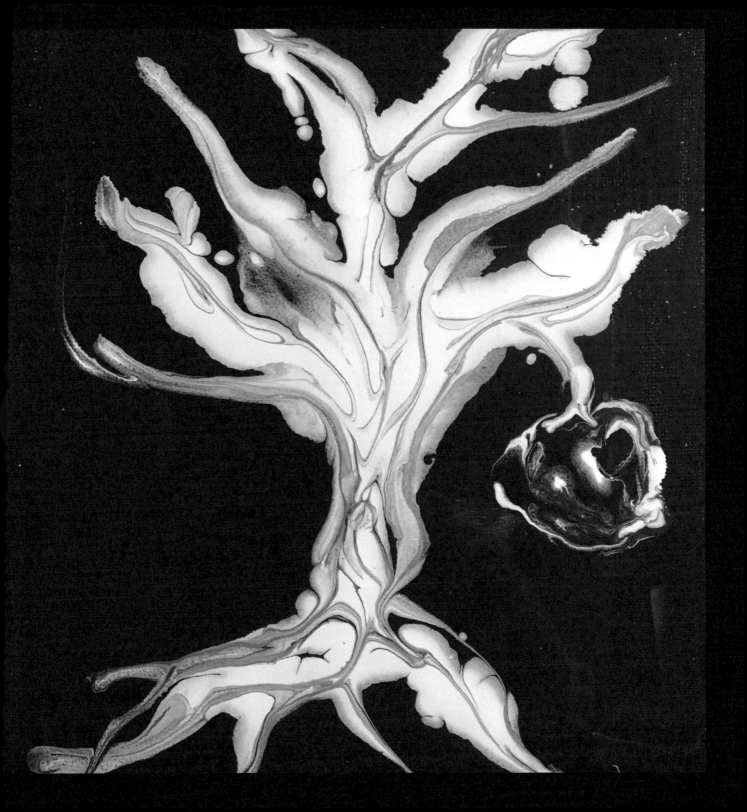

BECAUSE NOT EVERY TINY LIGHT

ACCEPTED THE INVITATION

TO BE LIGHT,

A STRUGGLE FOR POWER BEGAN.

THE WORLD

BECAME A PLACE OF

HURT AND ANGER.

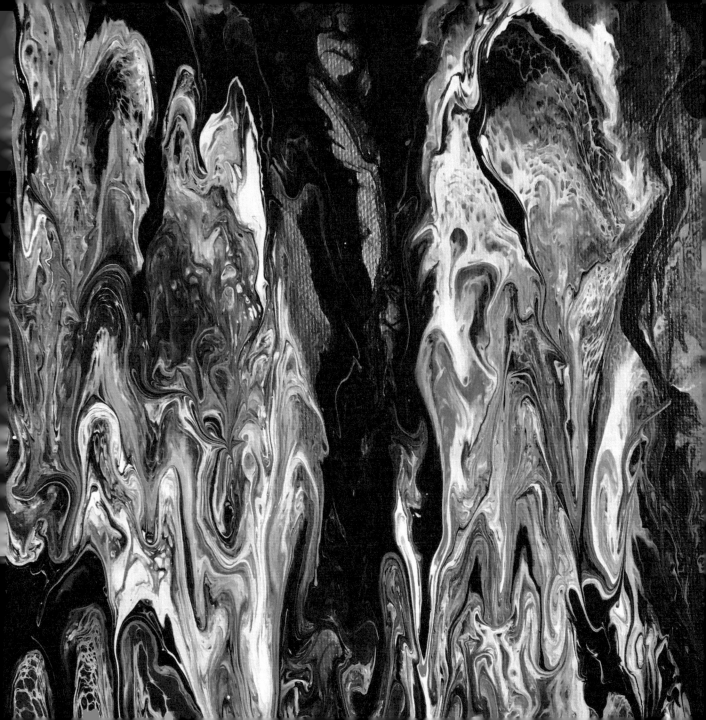

TINY LIGHTS HAD THE POWER OF THE
LIGHT,

BUT ONLY IF
THEY STAYED CONNECTED TO THE LIGH
AND EACH OTHER!

HOWEVER

WHEN TOO MANY TINY LIGHTS WENT
ASTRAY INTO DARKNESS, THE LIGHT

BECAME SAD AND ANGRY AND DESTROYE

ALL BUT A FEW TINY LIGHTS

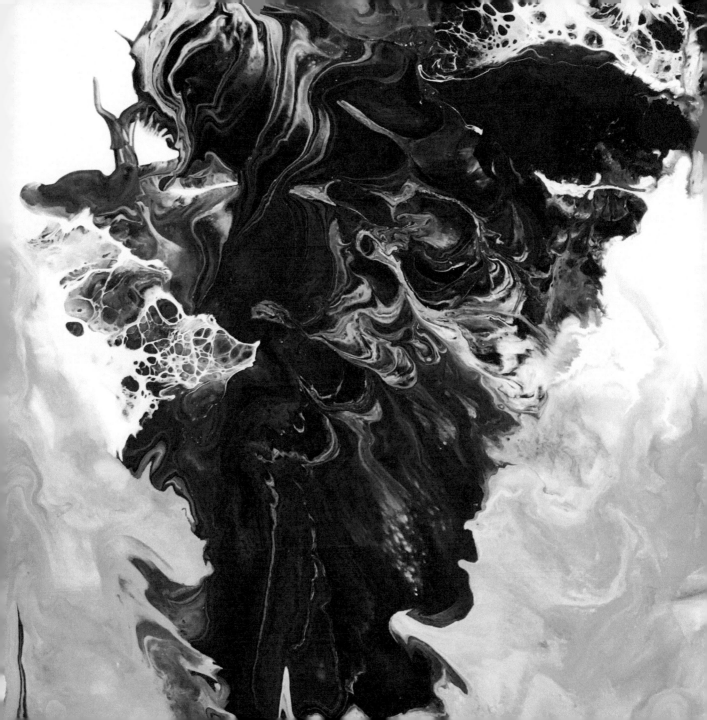

THE LIGHT WAS SAD

AND

DECIDED TO NEVER DO THAT

AGAIN

SENDING

A

SIGN TO THE TINY LIGHTS.

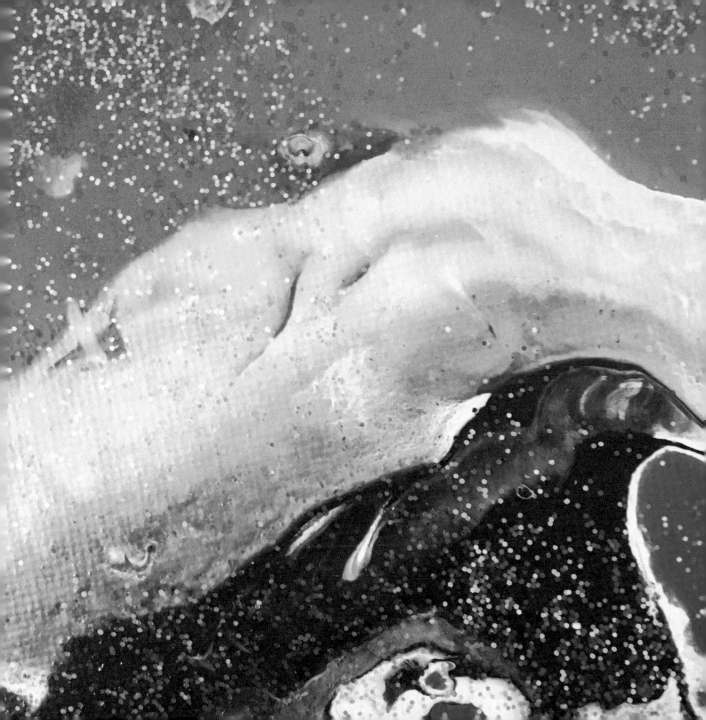

SO
LIGHT
EXTRACTED
A PIECE
OF ITSELF
AND SENT
IT TO THE
TINY
LIGHTS
FOR THE
COURAGE
TO LISTEN
AND
LOVE

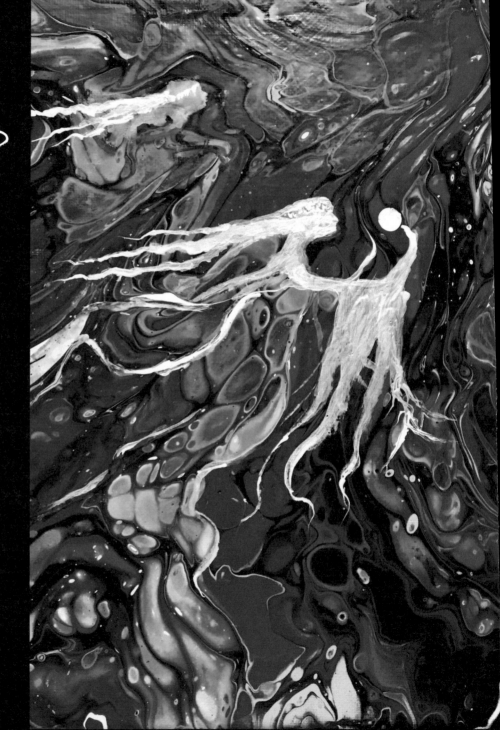

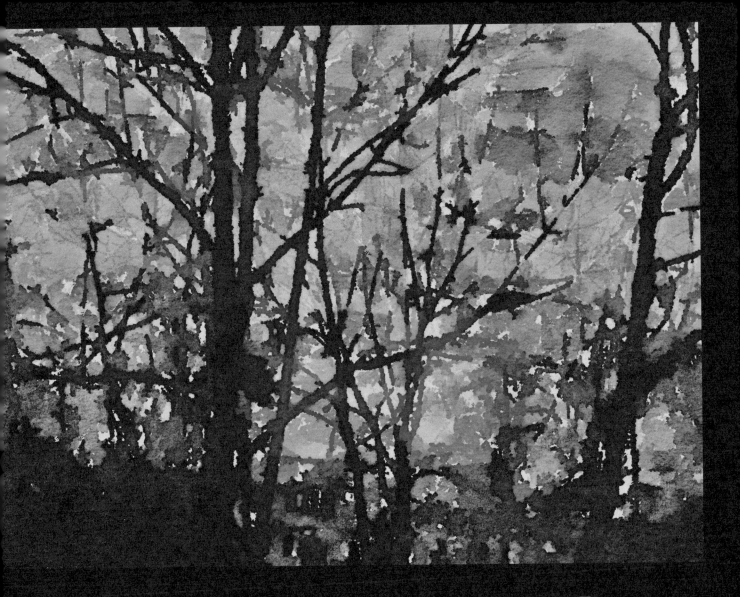

SOME TINY LIGHTS MURDERED
THE PIECE OF LIGHT

HORRIBLY.

EXCEPT

PEACE LIGHT

DID NOT EXTINGUISH

WHEN IT WAS

KILLED.

PEACE LIGHT WENT BACK TO

THE LIGHT

TO

LIVE FOREVER

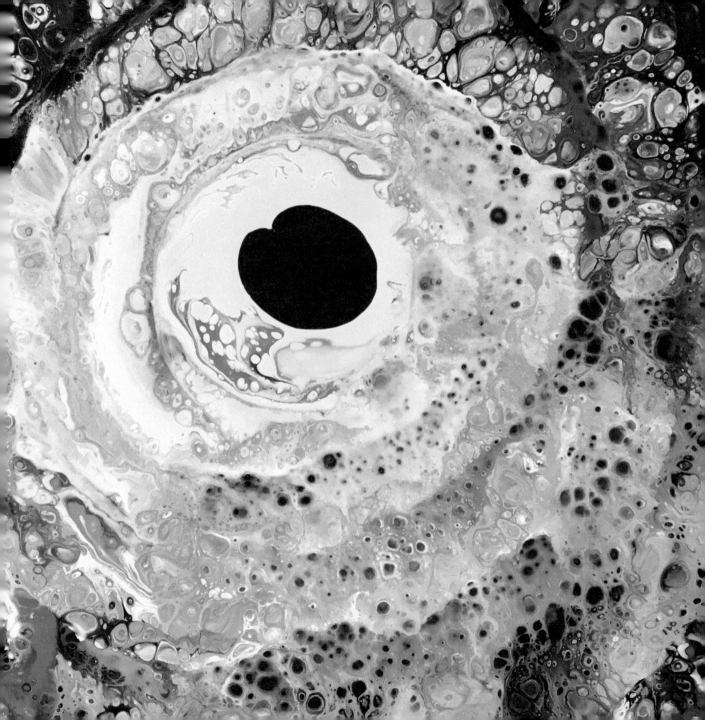

BEFORE PEACE LIGHT LEFT,

IT TOLD THE TINY LIGHTS, WHO LOVED LIGHT,

THEY TOO WOULD LIVE FOREVER.

THEY JUST NEEDED TO

BELIEVE

ACCEPT

LOVE

THOSE
WHO
BELIEVE
GO
HOME
TO
BECOME
PART
OF
THE
LIGHT
FOREVER

BEING DARK TO DARKNESS
ONLY CREATES MORE DARK
SO,

BE THE LIGHT!

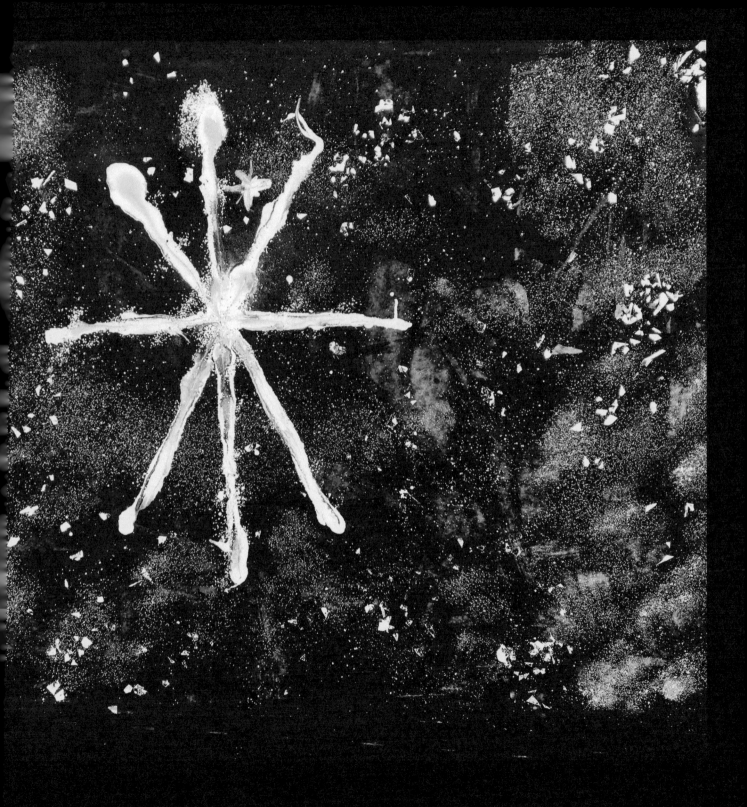

Dedicated to Robbie and Elena,

Two Courageous Tiny Lights!

Sgm has been a Fine Artist for over 18 years. With a Master's Degree in Counseling Psychology and a life long Christian, she pursues the integration of knowledge and inspiration.

Printed in the United States
By Bookmasters